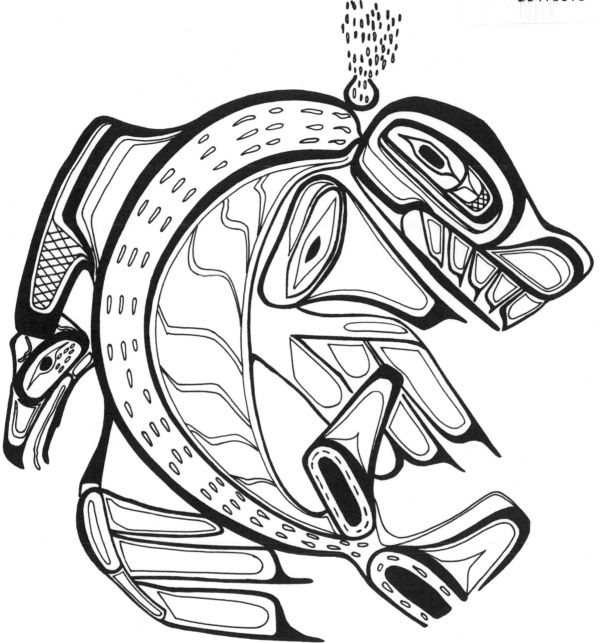

Caren Caraway

NORTHWEST INDIAN DESIGNS

Stemmer House
PUBLISHERS, INC.
OWINGS MILLS, MARYLAND

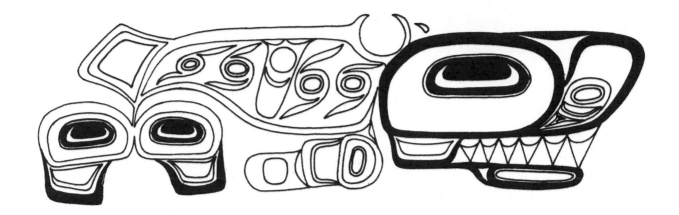

For Barbara Holdridge
who has given me so many opportunities to share with others.

With grateful appreciation to the generous staff members of the museums
whose works are included in this book.

Source material for this book courtesy of
American Museum of Natural History, New York, New York
Field Museum of Natural History, Chicago, Illinois
Portland Art Museum, Portland, Oregon
Thomas Burke Memorial Museum, University of Washington, Seattle, Washington
Museum of Anthropology, University of British Columbia, Vancouver, British Columbia, Canada
Museum of the American Indian, Heye Foundation, New York, New York
Denver Art Museum, Denver, Colorado

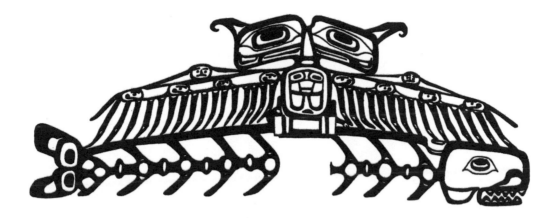

The Thunderbird *(Ganî'sldzwa)* caught a large whale. He wanted to create a country in which to live. He dropped the whale and it became an island which he called *Yā'laLē*ᵉ (stopping-on-water). In the beginning *Yā'laLē*ᵉ was drifting about. Then the eagle-ancestor tied it with a line to the mountain ᵉ*mE'nsgEmxLē*ᵉ in the *Ō'yala.idEx*ᵘ country. He fastened a second line to the mountain *Tɛ'nk.!ɛs*. Since the Eagle created *Yā'laLē*ᵉ all the people there belong to the eagle clan.

Told by *Aî'wagēl* to Franz Boas·

THE RAVEN TALE
Raven Steals the Sun.

In the beginning there was no sun, for a chief kept it as his property in a box, carefully tied up with ropes of cedar withes. Only the moon gave light to the people. Raven resolved to steal the sun. He flew to the village where the sun was being kept, transformed himself into a cedar leaf and let himself drop into the pond from which the people used to draw water. The chief's daughter sent a slave to bring water for her and Raven succeeded in getting into the bucket in form of a cedar leaf. Although he was carefully hidden in the corner of the bucket the girl discovered the leaf and had the water thrown away. Next he transformed himself into a salmon berry, but the girl said, "It is Raven," and had it thrown away; last he entered the bucket in the form of trout-fry *(golî'ste?)*, hid in the corner from which the girl used to drink and was swallowed by her. The girl became pregnant and in due time Raven was born by her. He cried because he wanted to play with the sun-box, shouting *gwagaᵉmats!e wē'*. Finally he was given the box. First he played with it in the house, then he went outside, going farther and farther until finally he flew away with it. First he went north to Skeena River. The people were catching olachen and he asked for three or four, promising in return to free the sun. He met a chief in another canoe which was full of olachen and upon his request the people gave him a few. Then he asked the chief and his family to place their canoe behind his, because he was going to open the box and change the world. He opened the box, and the sun came out. Those who had refused to give him olachen were transformed into frogs while those who were liberal were saved.

Told by Andrew Wallace to Franz Boas*
Bella Bella Tales

Bella Bella Tales. New York: The American Folk-Lore Society, G. E. Stechert & Co., Agent, New York, N.Y., 1932

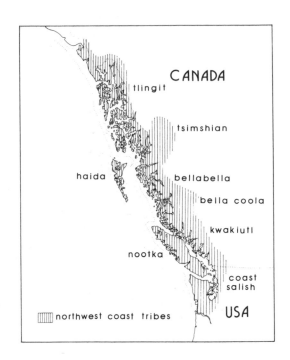

INTRODUCTION

The thunderbird, eagle, raven, wolf and killer whale were just a few of the totems that appeared in clan histories, myths and legends; giving to the Indians of the Northwest Coast certain privileges, along with household and clan crests.

Raven was the magical transformer who created the world and its living creatures; provided fish in the waters and plants on the earth; and placed the sun, stars and moon in the sky.

Such was the abundance he gave that a sophisticated, complex culture flourished along the thousand miles of jagged coastline extending from the Columbia River of Oregon to Yakuta Bay in Alaska. The magnificent, mysterious, rugged terrain, where densely forested mountains and rushing rivers met the sea with its countless islands, had a moderate climate and heavy rainfall. The natural resources of the lush environment supported a profusion of spirits, and a population of 60 to 70,000 human beings.

Life was oriented toward the sea along which transportation, trading and communication occurred, and from which most food came. Villages, sheltered in small bays, were composed of large wooden houses fronted by carved totem poles and lines of various kinds of superbly constructed canoes, necessary for long trading voyages and shorter fishing expeditions.

During the summer months, families gathered food. They fished the teeming rivers and ocean, with salmon considered the prized catch. Sea life, whales and plants provided additional foodstuffs. No agriculture was developed, therefore, and the dog was the only domesticated animal.

The abundant food supply gave ample leisure time for the creation of a complicated social structure organized according to social status. Households, the basic family units, consisted of blood and clan relatives. Clans claimed relationship through descent from a common mythical ancestor who received privileges from a supernatural being. Clans formed tribal divisions whose relationships were described by legend. There were seven distinct language divisions, but all were part of a closely related culture. Groups were generally patrilinear in the south, while those in the north were matrilinear.

Privileges, which were regarded as valuable property, gave status. They were acquired by inheritance, marriage, gift or murder; and celebrated in elaborate ceremonies and festivals.

Families which had the most privileges held highest rank. The competition for status led to a megalomanic desire for material wealth, which established rank and affected many aspects of life, such as marriages, some of which were polygamous.

The accumulation and extravagant distribution of riches brought prestige. Potlatch ceremonies were held to celebrate particular events, elevate social status, and shame rivals. For several days

excessive feasting, historical and self-serving speeches, dances and drama took place. There was a lavish display of family crests which symbolically expressed the power of the totem spirits and proclaimed the rank of their owners. Slaves were sometimes killed, given away or freed. Blankets, furs, coppers and other items were given away with the knowledge that more would later be returned, unless the guests accepted disgrace. On occasion greater glory was sought as objects were broken, burnt or cast into the sea in an expression of contempt for the value of the goods destroyed.

A complex mythology detailed supernatural contacts, for the Indians strongly believed in communication with the spirit world during trances and dreams. Many supernatural beings were personified. Some were benign, other evil. Rituals were conducted to maintain the proper relationship with fish and animal spirits. Spirit-quests were undertaken in an attempt to receive gifts of power from the supernatural. Winter ceremonials featured dances and songs obtained from the spirits. These events also required ornate paraphernalia such as masks, drums and rattles.

Thus there was a great need for skilled artists whose works established and advanced the position of their patrons, and fulfilled the requirements of the numerous rituals.

The purpose of the art of the Northwest Coast tribes was to depict the totemic crest. It was decorative, with the subject—generally an animal, human or mythical being—adjusted to the function, form and size of the object to which it was applied. This was done with various degrees of realism, and with fundamental changes in size and arrangement of parts. In order to fit the design to the decorative field, the subject could be stylized, split, distorted, x-rayed, flattened, unfolded, bent, exaggerated, eliminated or rearranged. It could be combined with another, only partially portrayed or represented by a symbol, which was a substitute for the unknown written word. Conventional symbols were developed to represent important characteristics. For instance, a killer whale was recognized by a large head, toothed mouth, blow hole and dorsal fin; while a bear had large paws, a wide mouth with teeth and protruding tongue. Some stylized design units were used repeatedly and interchangeably, indicating the concept of the oneness of all living things and their ability to transform at will.

There was a highly developed system of symbols and organization of form and space. The formlines were mainly curvilinear with a continuous, contoured line structuring, delineating and harmoniously distributing the essential features. Remaining spaces were filled by secondary units and elaborated with other details. Texture added interest and variation.

The natural abundance of wood provided limitless material for carving, which was the principle technique. Men also painted and used metal, stone, bone, ivory, shell, horn and leather. Women worked with textiles and basketry. There was no pottery. Carved objects were the most common, existing as totem poles, masks, rattles, boxes, dishes, etc. Paint was used, not only to embellish the three-dimensional items, but to create two-dimensional designs on house fronts, screens and human bodies.

Paint was made from natural pigments such as charcoal, minerals and vegetable matter mixed with chewed salmon eggs. The most important color was black, which was generally used for the primary design elements. Red colored the secondary units and was the usual hue for certain details such as the tongue. Blue-green and white were also important colors.

There were some tribal variations, but generally the art of the various groups was similar in certain functions, forms and concepts. Working within a highly traditional system, the energetic artists of the Northwest Coast creatively developed an elaborate, powerful art that richly portrayed the family crests and ancestral myths that were such an integral aspect of the lives of their people.

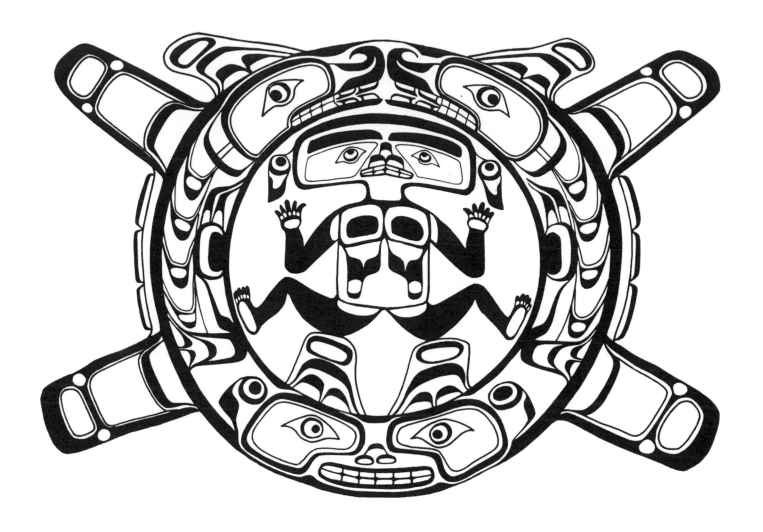

Front Cover Haida box drum from Queen Charlotte Islands. Bear. Collected by James Deans before 1893. *(Field Museum of Natural History, Chicago)*

Title Page Haida hide drum from Queen Charlotte Islands. Killer whale. *(A4257 Museum of Anthropology, University of British Columbia, Vancouver)*

Dedication Page Haida buckskin bag containing face paint from Queen Charlotte Islands. Killer whale *(17995 Field Museum of Natural History, Chicago)*

Above ⌣ Kwakiutl ceremonial curtain from Kingcome Inlet. Attributed to Arthur Shaughnessy. Sisiutl and Human. *(A4363 Museum of Anthropology, University of British Columbia, Vancouver)*

1 Haida cedar box drum. *(79599 Field Museum of Natural History, Chicago)*

Introduction Kwakiutl chief's painted housefront from Alert Bay, British Columbia. Thunderbird carrying a whale.

2 Nootka Panel. Thunderbird carrying a whale, with wolf and lightning snake. Painted cedar planks. Made about 1850. Collected by G. T. Emmons in 1929. *(16./1892A American Museum of Natural History, New York)*

3 Haida dance shirt. Eagle and bear with dance hat. Appliqued flannel on a Hudson's Bay Company blanket. Collected by James G. Swan, 1893. *(1. Burke Museum, University of Washington, Seattle)*

4 Haida cloth shirt from Queen Charlotte Islands. Dog fish. Applique. *(17982 Field Museum of Natural History)*

5 Haida slate dish. Killer whale. *(From Boas, American Museum of Natural History, New York)*

6 Haida slate dish. Sea-monster. *(From Boas, American Museum of Natural History, New York)*

7 Haida slate box. Sculpin. *(From Boas, American Museum of Natural History, New York)*

8 Haida slate box. Sea-monster. *(From Boas, American Museum of Natural History, New York)*

9-10-11 Tsimshian chief's chest from Skeena River, British Columbia. *(18632 Field Museum of Natural History, Chicago)*

12 Haida wooden box. *(53039 Field Museum of Natural History, Chicago)*

13 Haida Copper from Skidegate, Queen Charlotte's Islands. Grizzly Bear eating a boy. *(85039 Field Museum of Natural History, Chicago)*

14 Tsimshian ceremonial rattle. Double face. *(14276 Field Museum of Natural History, Chicago)*

15 Salish spindle whorls. Thunderbirds. *(85370, 85375 Field Museum of Natural History, Chicago)*

16 Salish spindle whorl. Mythical crested lake monster. *(85373 Field Museum of Natural History, Chicago)*

17 Haida slate carving from Skittagettar, Queen Charlotte Islands. Killer whales, bears and human beings. *(14373 Field Museum of Natural History, Chicago)*

18 Haida carved slate dish from Queen Charlotte Islands. *(17952 Field Museum of Natural History, Chicago)*

19 Haida tatoo patterns. *(79790, 79790-2, 79790-4, 79790-8, 79790-11, 79790-12 Field Museum of Natural History, Chicago)*

20 Tlingit canoe ornament perched on prow of sixty-foot canoe. Used by the Raven division at Klukwan, largest Chilkat Tlingit village. Owl with outstretched wings. Carved and painted wood inlaid with abalone and trimmed with brown bear fur. Collected by Lt. G. T. Emmons, 1902. *(79320 Field Museum of Natural History, Chicago)*

21 Tsimshian sun mask worn as chief's ceremonial headdress, from Nass River, British Columbia. Human face with sun rays painted with sea-monster designs. *(18/5783 Museum of the American Indian, Heye Foundation, New York)*

22 Kwakiutl sun mask from Kingcome Inlet. Carved by Arthur Shaughnessy and used at Gilford Island in 1918. Shown with rays open. *(A3553 Museum of Anthropology, University of British Columbia, Vancouver)*

23 Kwakiutl chief's headdress from Alert Bay. Raven and Sisiutl, the double-headed serpent. *(A3731 Museum of Anthropology, University of British Columbia, Vancouver)*

24 Kwakiutl movable mask. Man's head with two mythical fish. Closed to reveal outer face. 1850-1900. *(14/9626 Museum of the American Indian, Heye Foundation, New York)*

25 Kwakiutl transformation family-crest mask, from Northern Vancouver Island, British Columbia. The outside of the mask represents the sun, the inside face symbolizes the sun's inner spirit when the mask is open. Late 19th century. *(Museum of the American Indian, Heye Foundation, New York)*

26 Tlingit man's shirt from Alaska. Woven from goat hair on cedar-bark base. 1890-1900. *(18/7902 Museum of the American Indian, Heye Foundation, New York)*

27 Tlingit Chilkat blanket from Cape Prince of Wales, Alaska. Brown bear. Woven from goat's wool on shredded cedar-bark base. Collected by Lt. G. T. Emmons, 1907. *(9/7438 Museum of the American Indian, Heye Foundation, New York)*

28 Tlingit Chilkat blanket. Hoorts, the Bear. *(19587 Field Museum of Natural History, Chicago)*

29 Bella Bella cedar coffin. *(19978 Field Museum of Natural History, Chicago)*

30 Lower Thompson Salish wool robe. Woven from colored yarns and unraveled and respun Hudson's Bay blankets. From Fraser River Canyon, Spuzzum, British Columbia. *(19133 Field Museum of Natural History, Chicago)*

31 Tlingit Chilkat dance leggings. Bear supported by a bird. Leather embroidered with porcupine quills. *(155568 Field Museum of Natural History, Chicago)*

32 Haida box drum from Queen Charlotte Islands. Bear. Collected by James Deans before 1893. *(Field Museum of Natural History, Chicago)*

33 Tlingit skin drum. *(The Denver Art Museum, Denver)*

34 Totem, Thunderbird Park, Victoria, British Columbia

35 Tlingit Sun and Raven pole. Three adventures of Raven. Carved 1902. *(Now at Saxman Totem Park, Ketchikan, Alaska)*

36 Kwakiutl ceremonial curtain from Campbell River. Thunderbird. Painted cotton. *(A4024 Museum of Anthropology, University of British Columbia, Vancouver)*

37 Kwakiutl ceremonial curtain from Alert Bay. Attributed to Arthur Shaughnessy. Thunderbird. *(A3773 Museum of Anthropology, University of British Columbia, Vancouver)*

38 Haida painting. Shark. *(From Boas, American Museum of Natural History, New York)*

39 Haida Tatoo. Sea-monster Tsem'aks, with a raven's body with whale body attached to its head and fin on back. *(From Boas, American Museum of Natural History, New York)*

40 Unknown tribe. Beaver, painted white buckskin. *(PAM 48.3.560 Rasmussen Collection of Northwest Coast Indian Art, Portland Art Museum, Portland)*

41 Tlingit center-painted partition screen for house of Chief Shakes, Wrangell, Alaska. Brown bear, principal clan-crest of the Shakes family. c. 1840. *(QTI-41 The Denver Art Museum, Denver)*

42 Haida painting. Bear. *(From Boas, American Museum of Natural History, New York)*

43 Tsimshian painted house front. Bear. *(From Boas, American Museum of Natural History, New York)*
44 Kwakiutl painted cedar bark mat from British Columbia. Plumed serpent. *(19/5016 Museum of the American Indian, Heye Foundation, New York)*
45 Kwakiutl canoe. Raven. *(American Museum of Natural History, New York)*
46 Bella Coola long dish. *(18251 Field Museum of Natural History, Chicago)*
47 Haida spruce root cradle. Dog-fish crest of weaver Mrs. Charles Edenshaw, wife of the most famous Haida carver, who may have painted the crest. *(Field Museum of Natural History, Chicago)*
48 Kwakiutl canoe. Killer whale. *(American Museum of Natural History, New York)*
49 Nootka panel. Thunderbird carrying a whale, with wolf and lightning snake. Painted cedar planks, made about 1850. Collected by G. T. Emmons in 1929. *(16.1/1892B American Museum of Natural History, New York)*
End Page Kwakiutl ceremonial curtain from Fort Rupert or Kingcome Inlet. Sisiutl, ravens, rainbow and copper. Painted cotton. *(A6270 Museum of Anthropology, University of British Columbia, Vancouver)*
Tlingit Raven screens of the Huna. Painted cedar boards. *(PTI-3a The Denver Art Museum, Denver)*
Back Cover Tlingit Chilkat blanket. Killer whale. *(19571 Field Museum of Natural History, Chicago)*

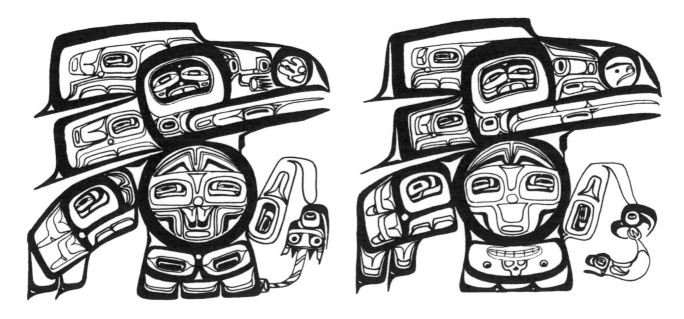

Tlingit Raven screens of the Huna. Painted cedar boards. *(PTI-3a The Denver Art Museum, Denver)*

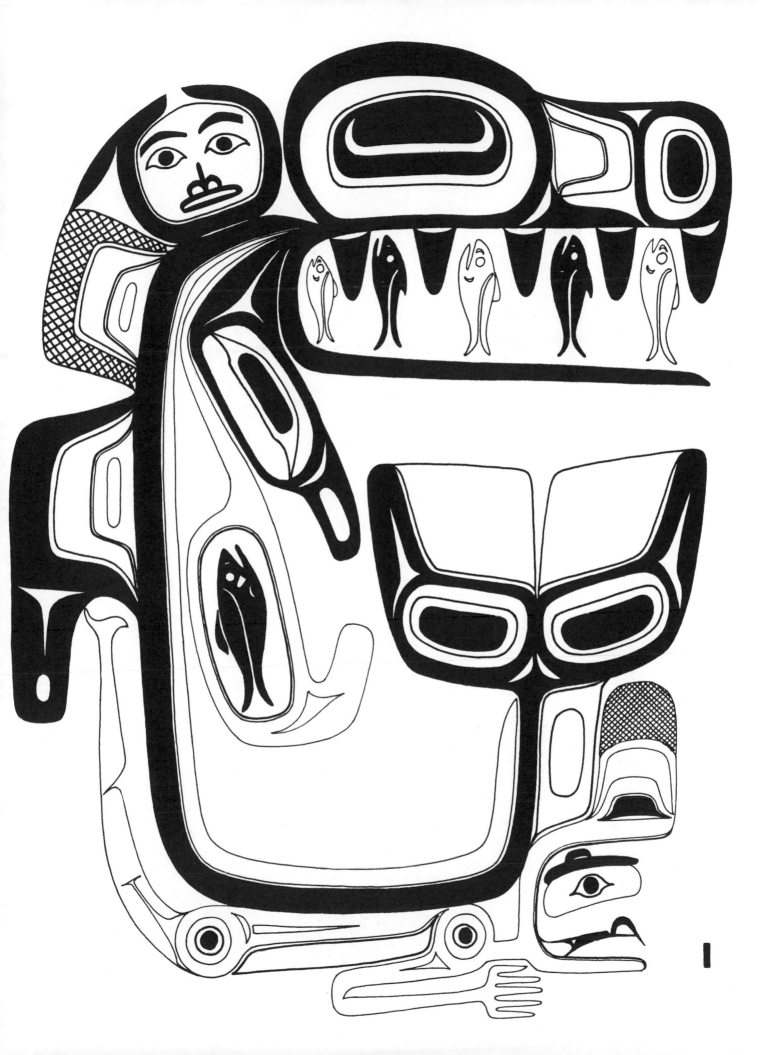

I

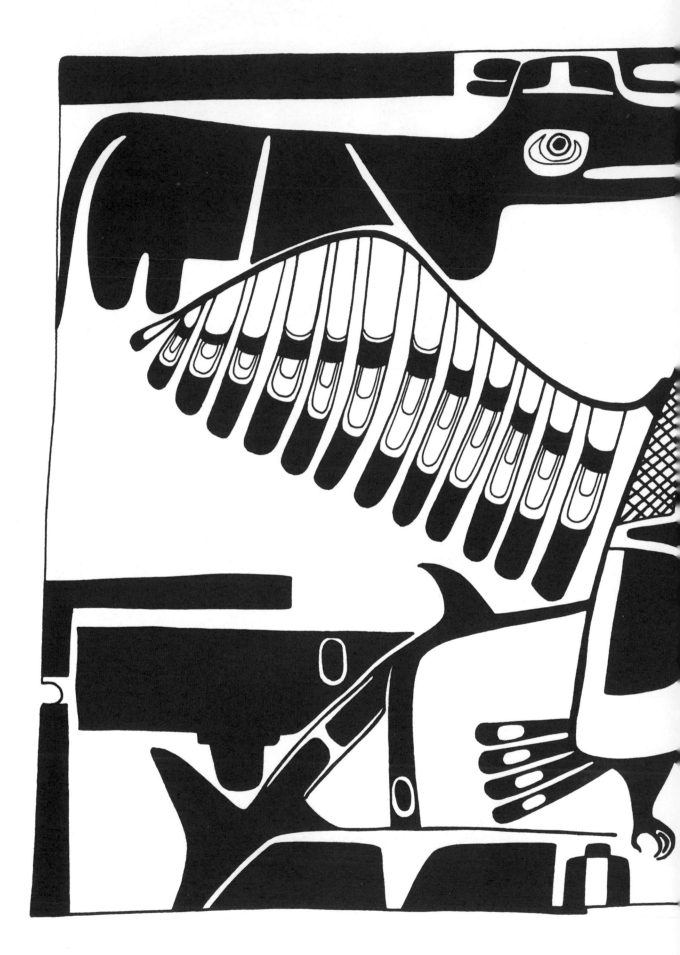

2

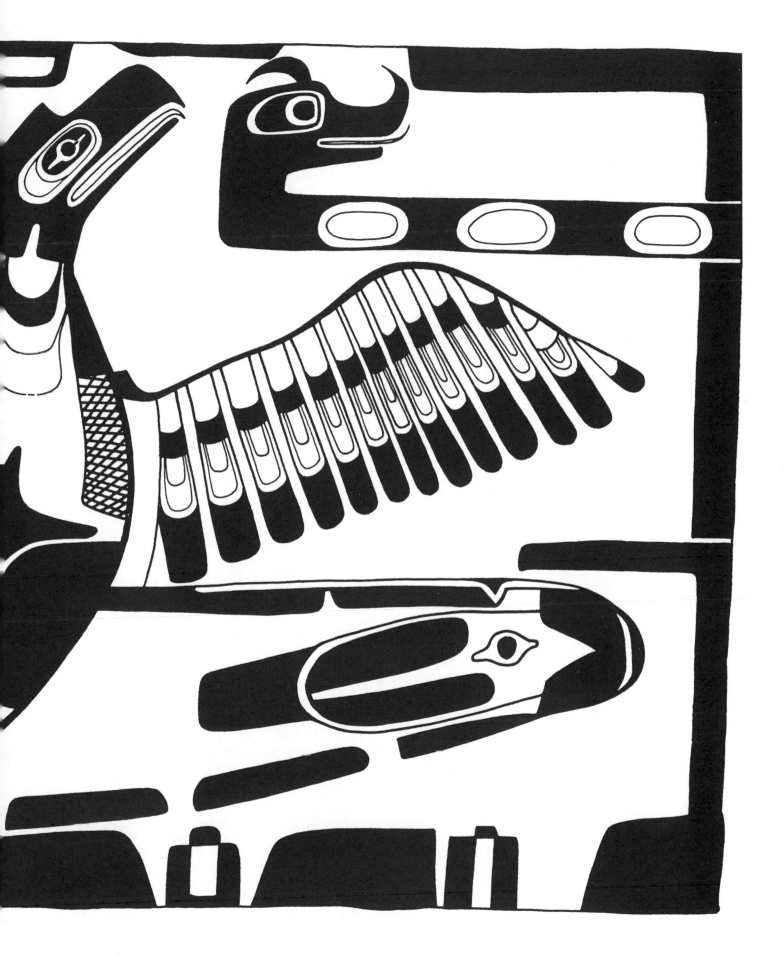

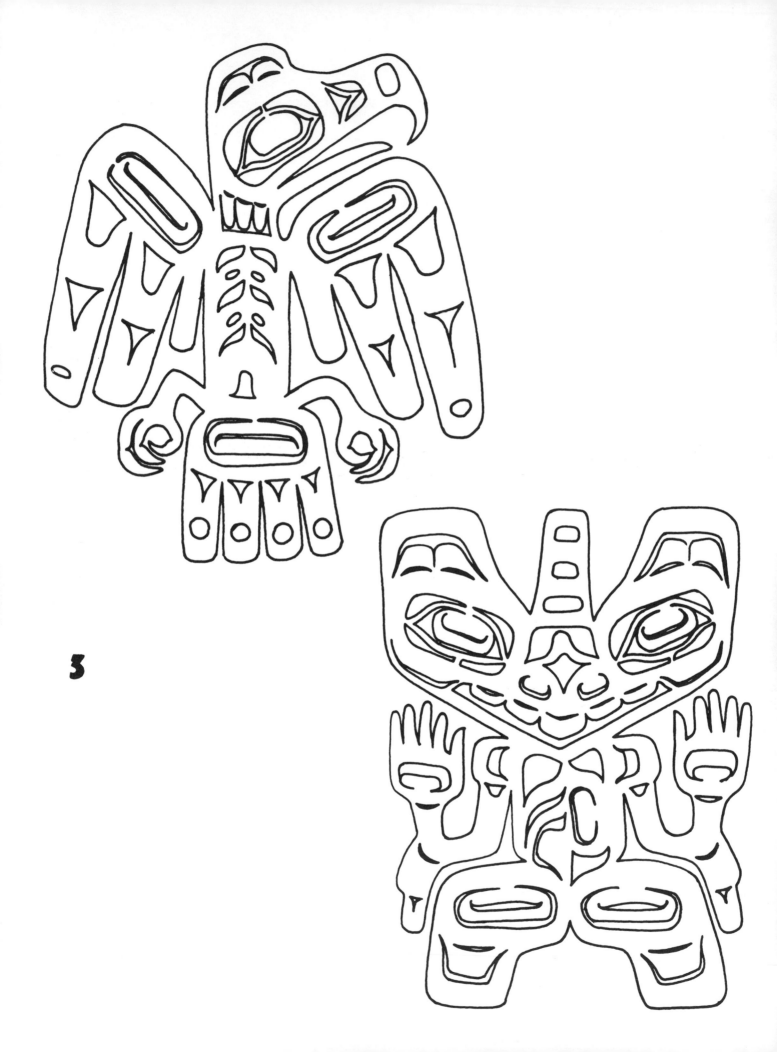

3

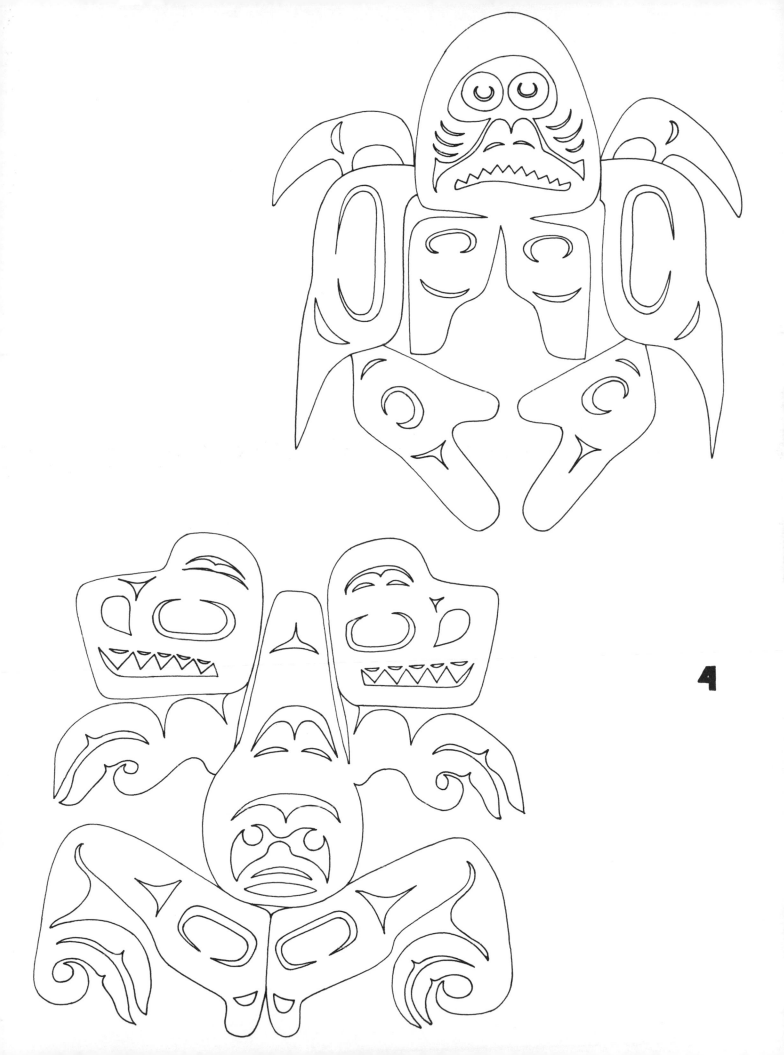

4

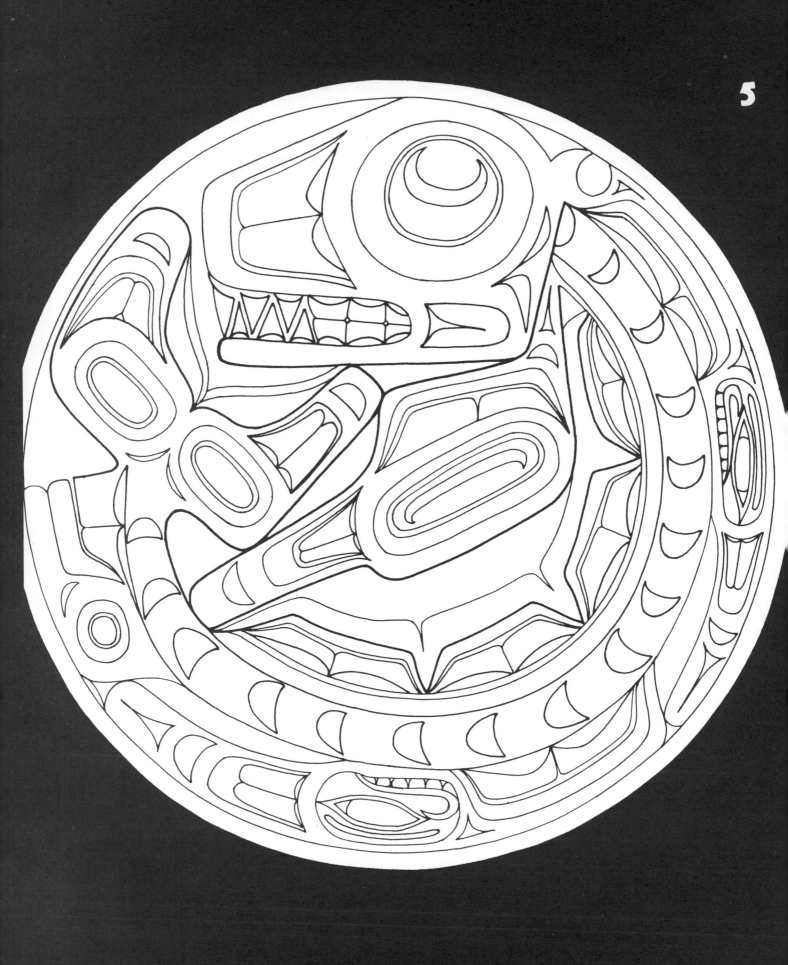

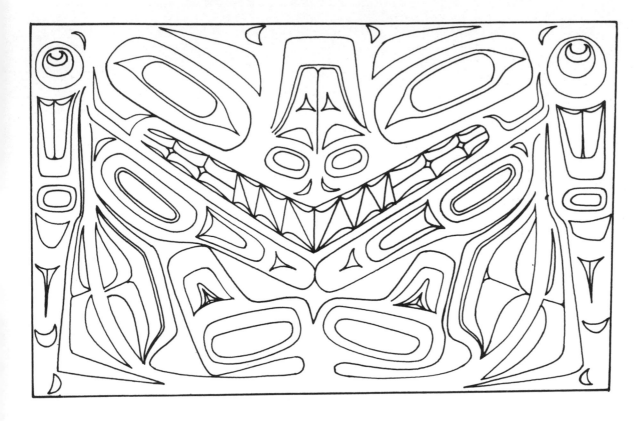

7

9

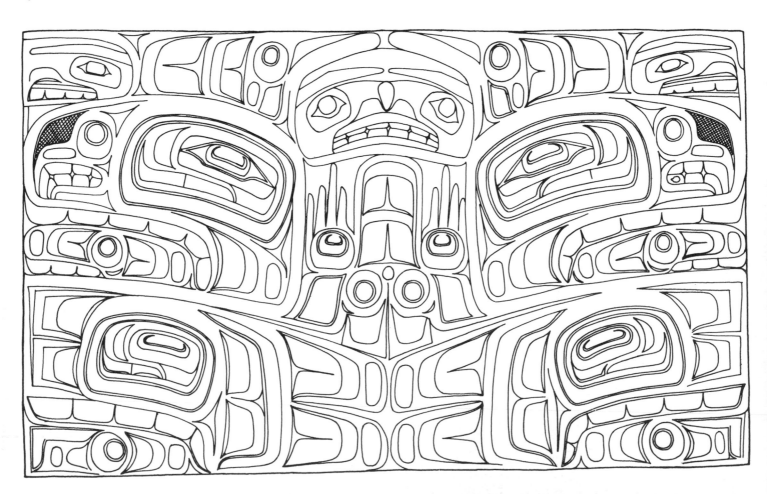

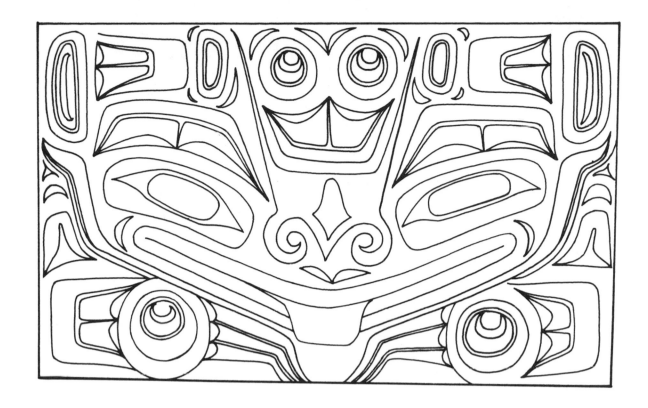

8

10

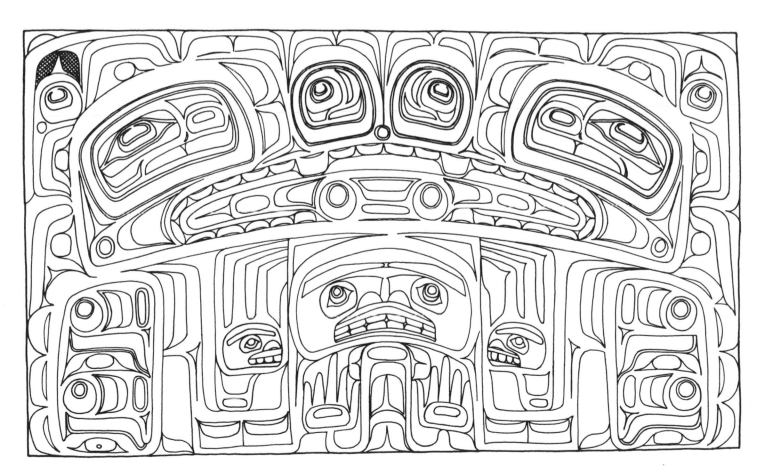

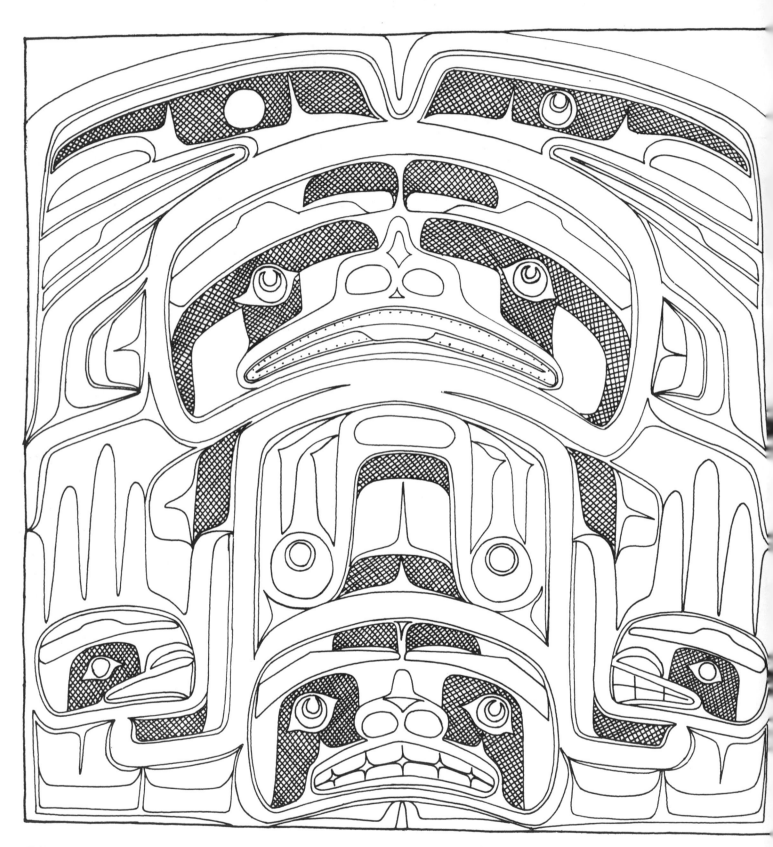

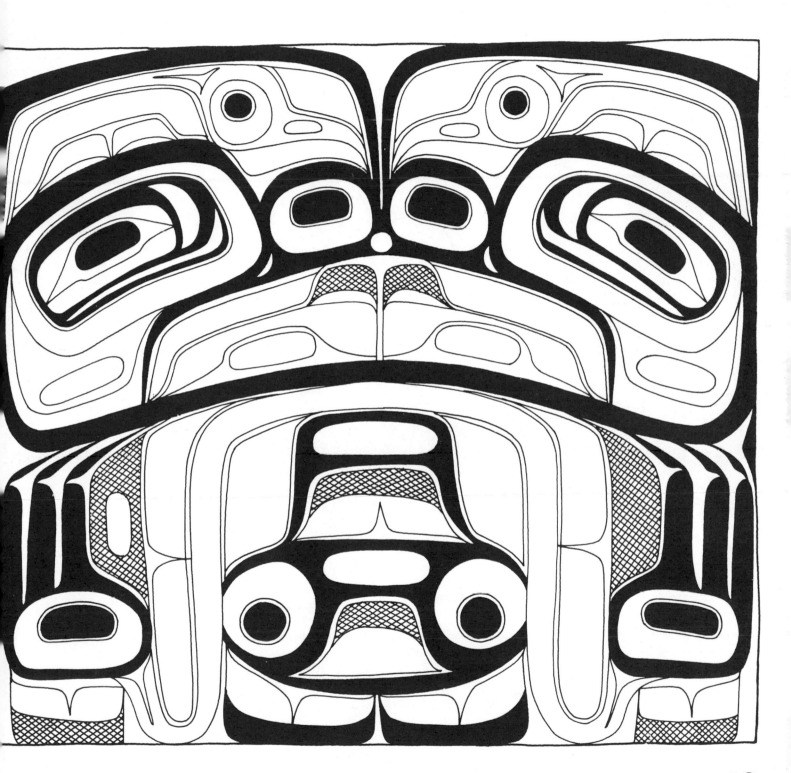

12

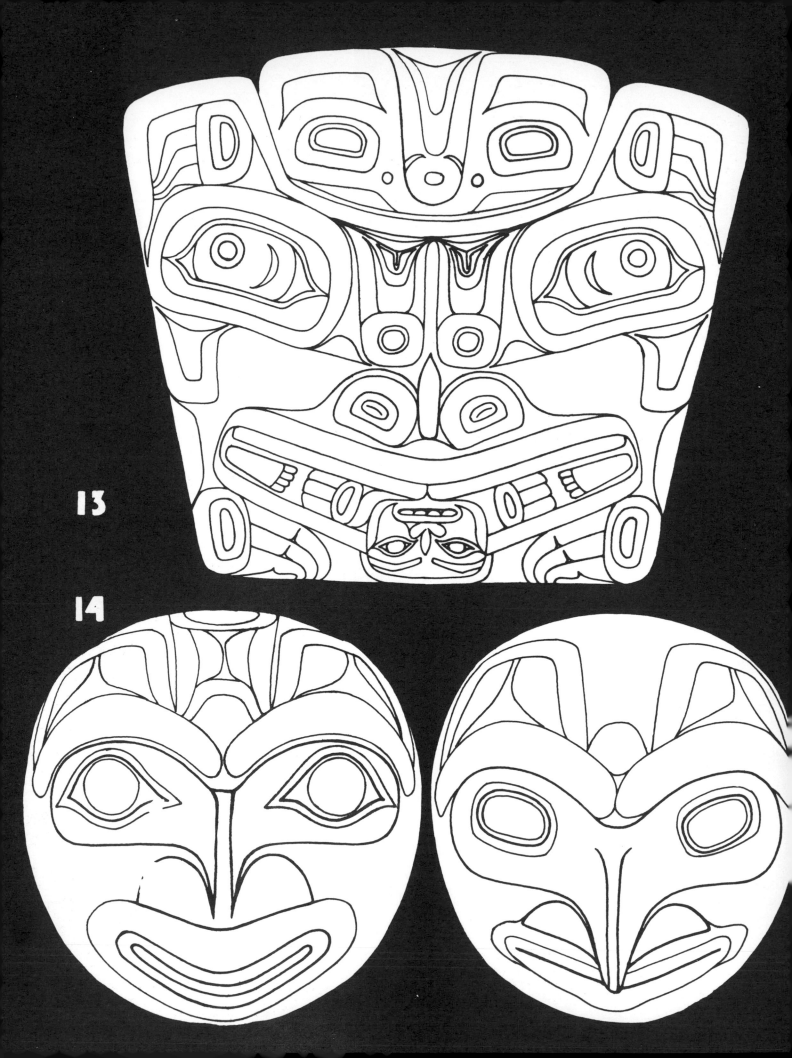

13

14

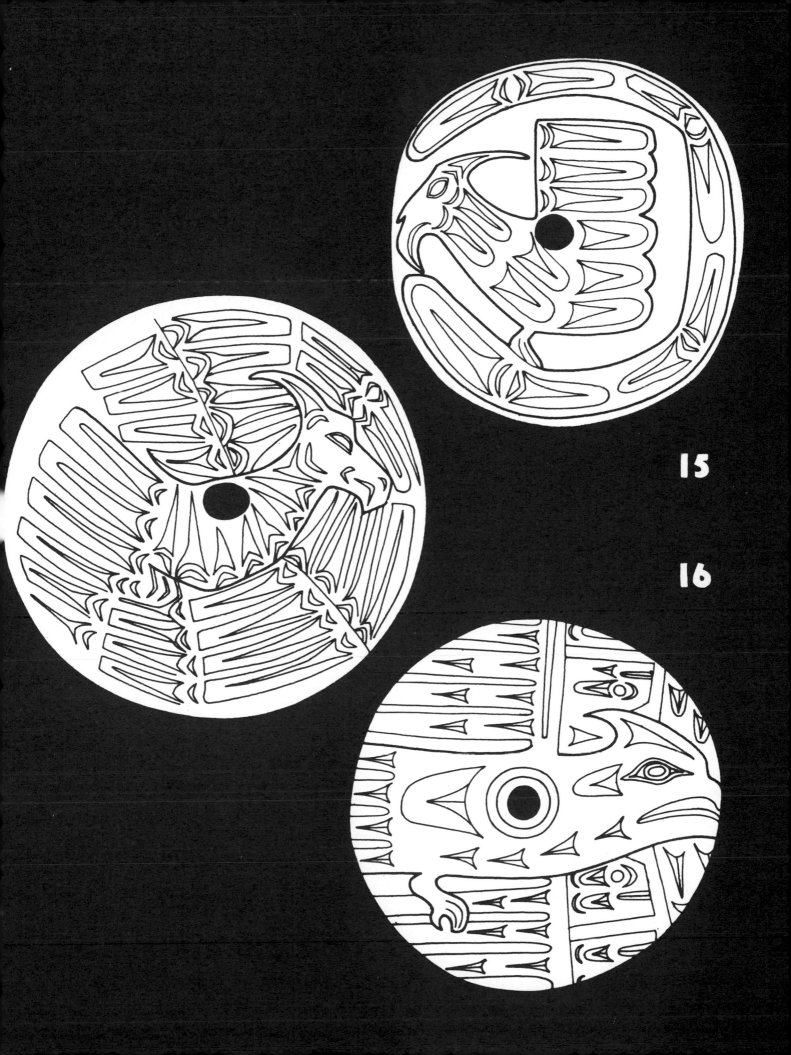

15

16

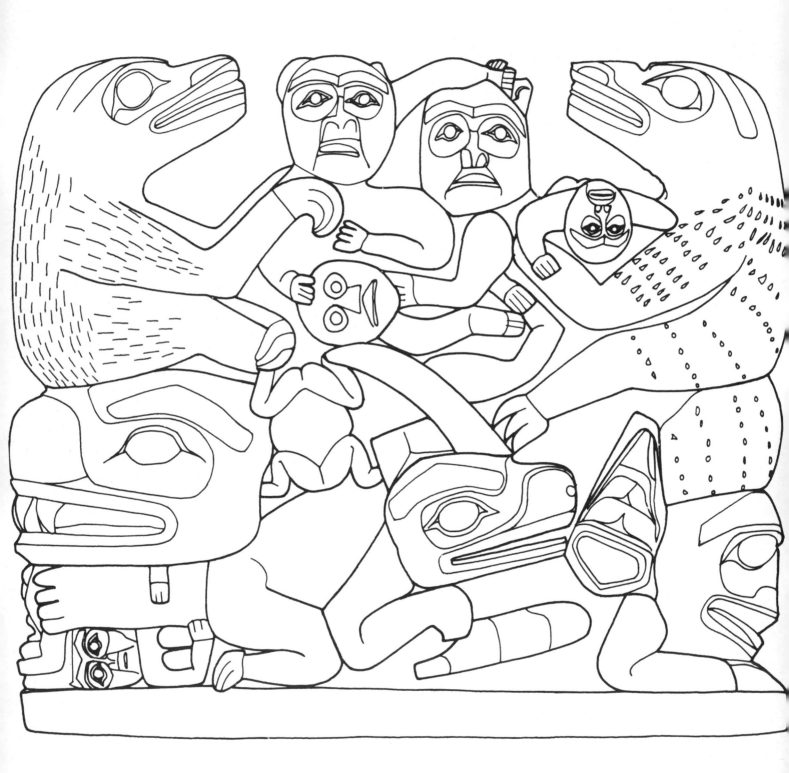

18

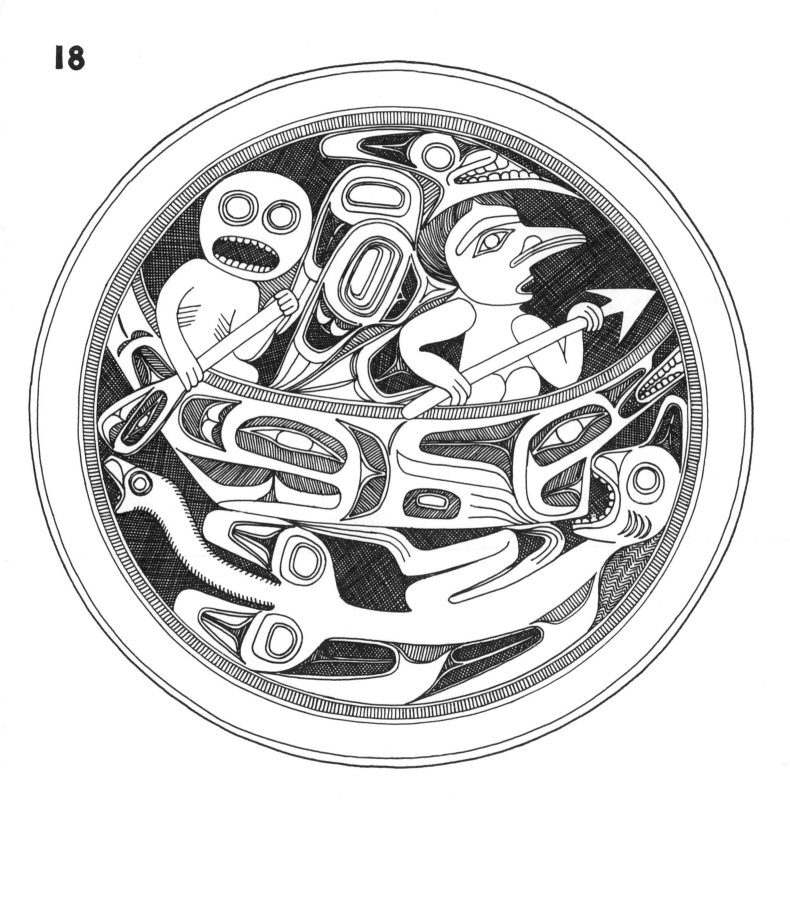

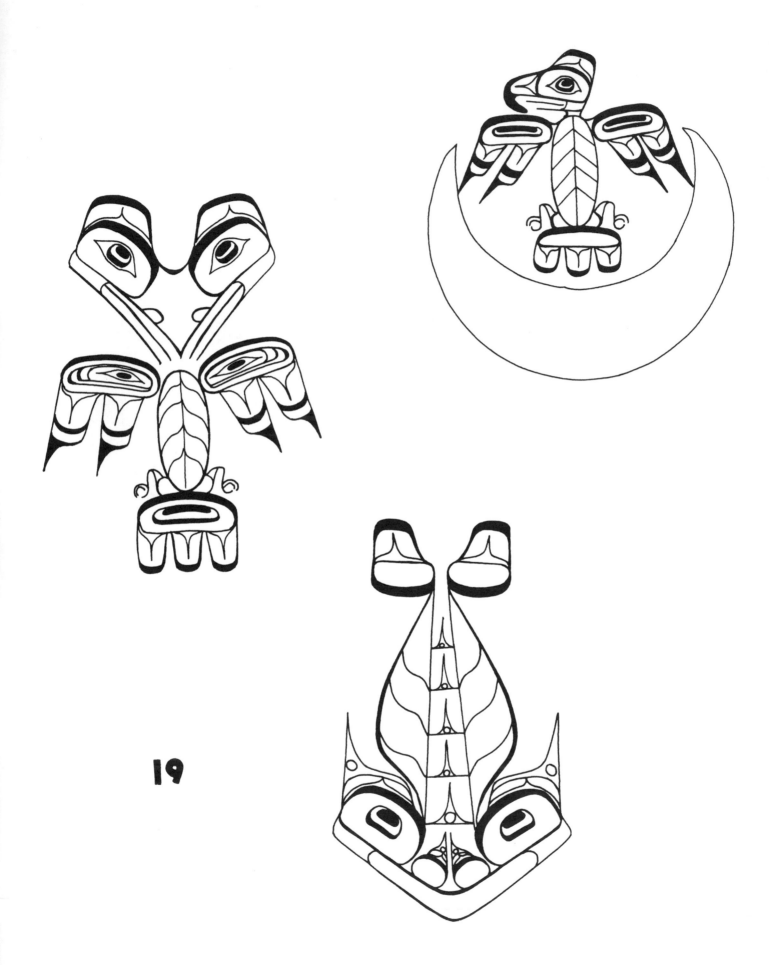

19

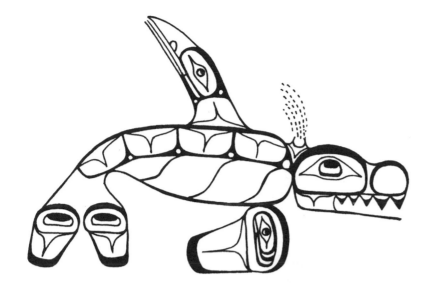

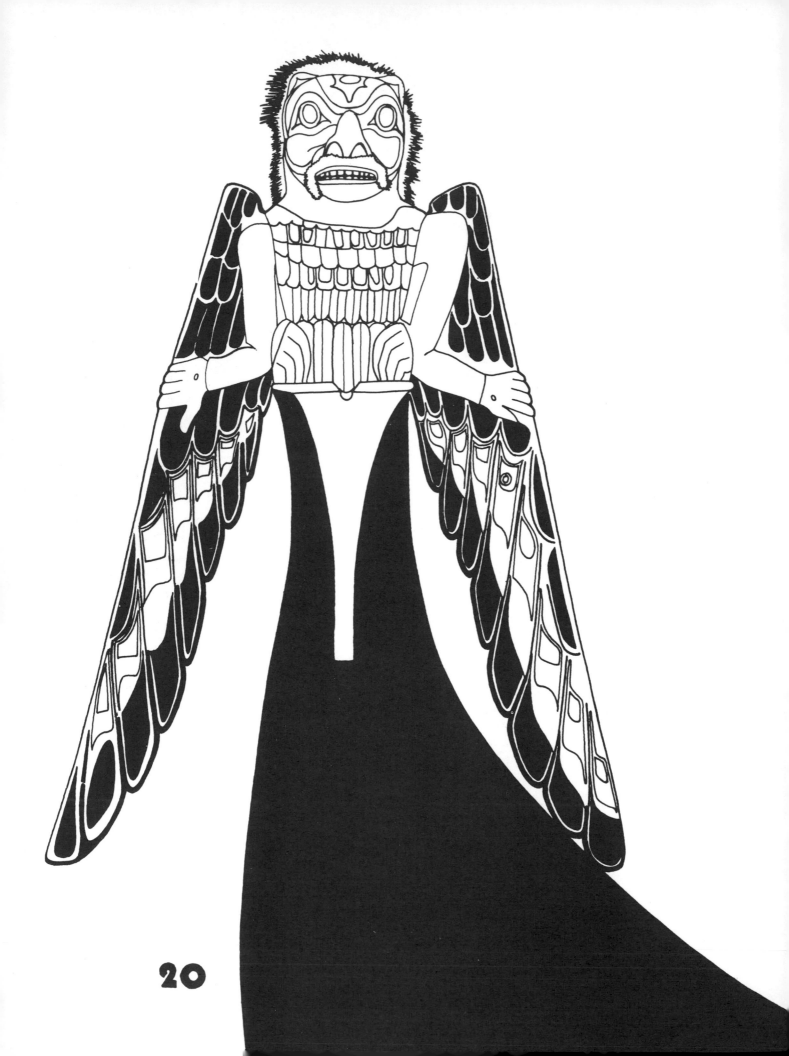

20

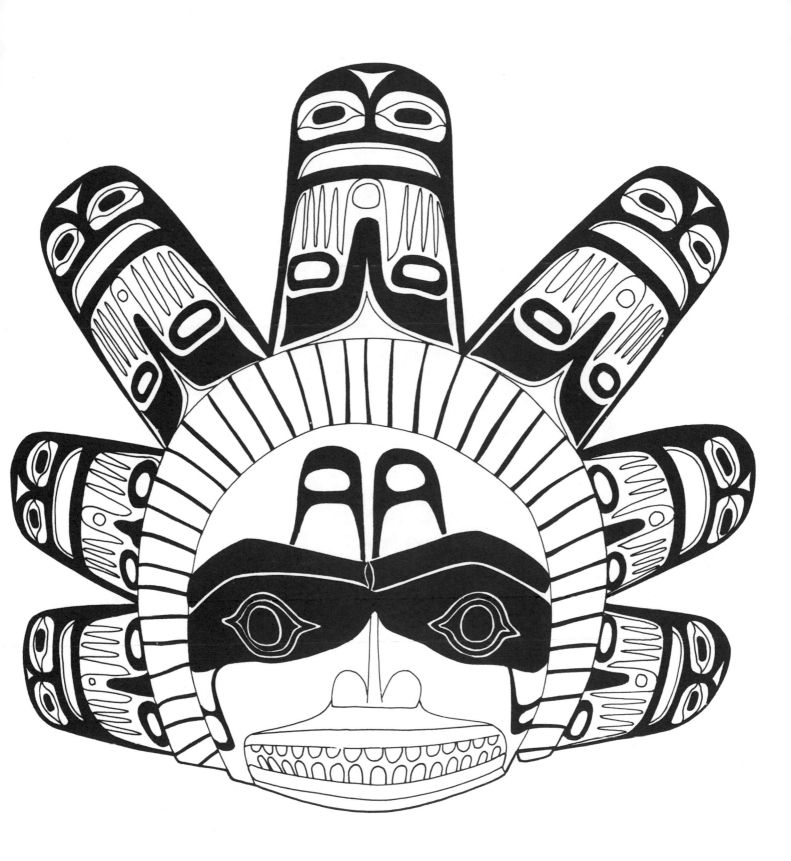

21

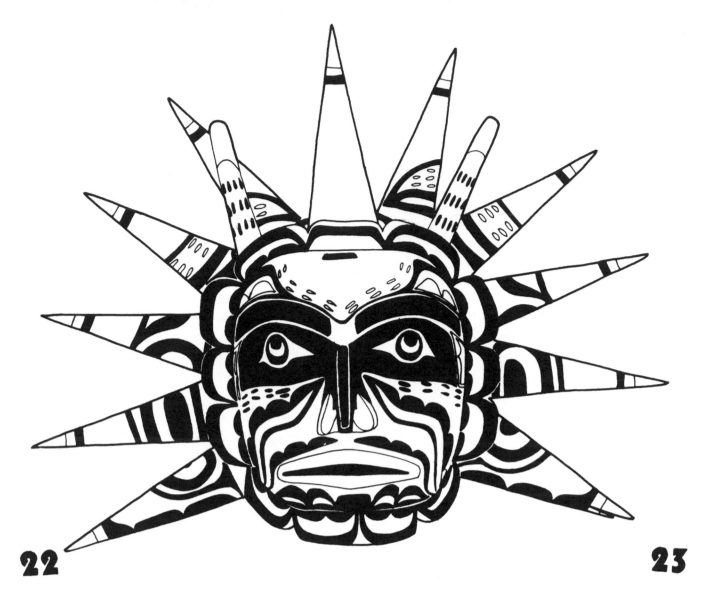

22

23

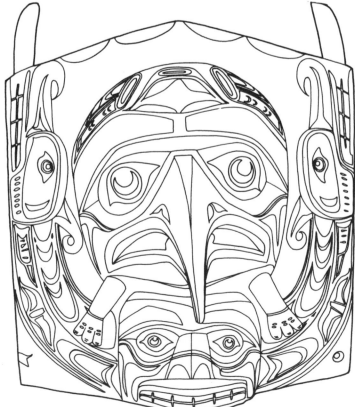

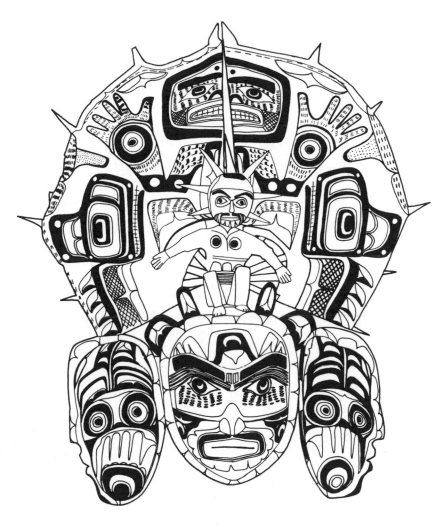

25

24

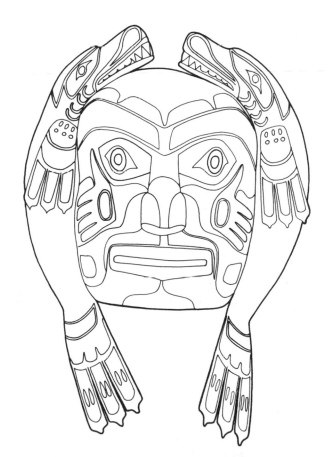

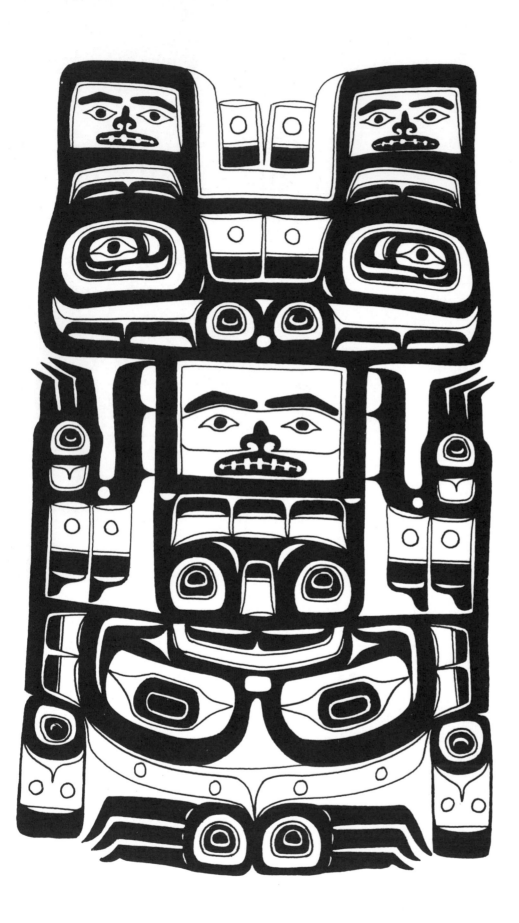

26

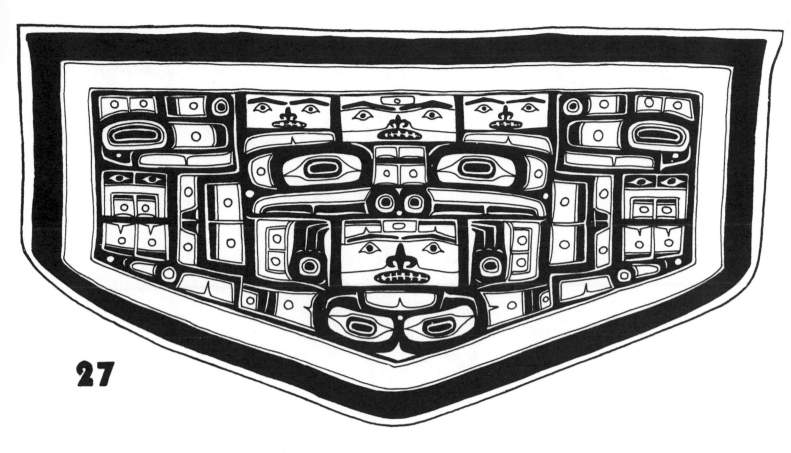

27

28

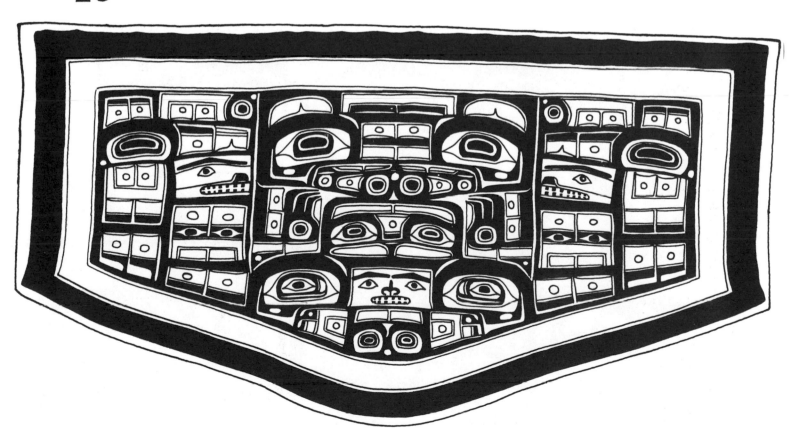

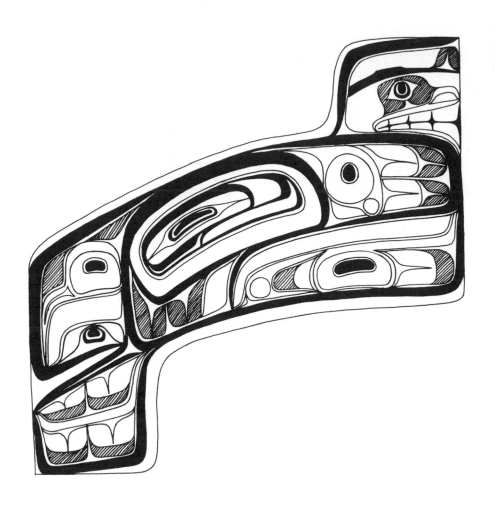

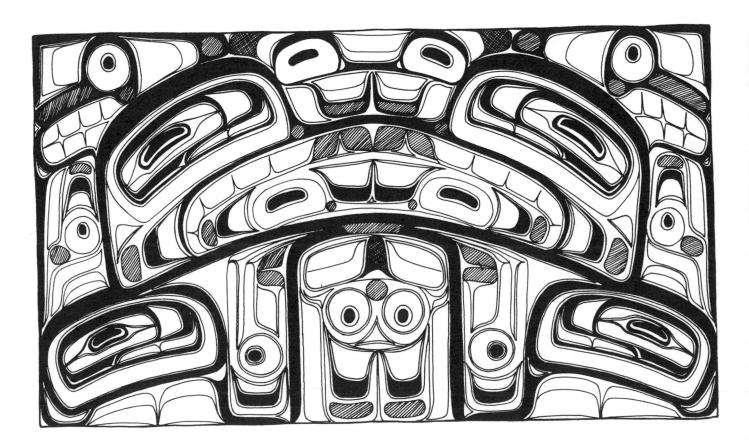

29

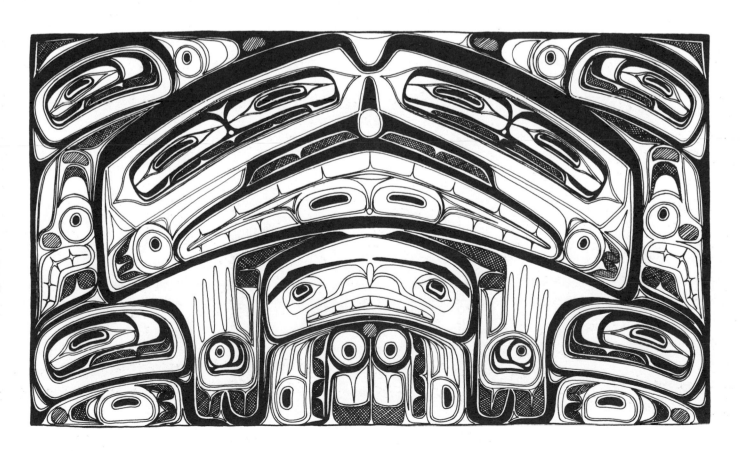

30

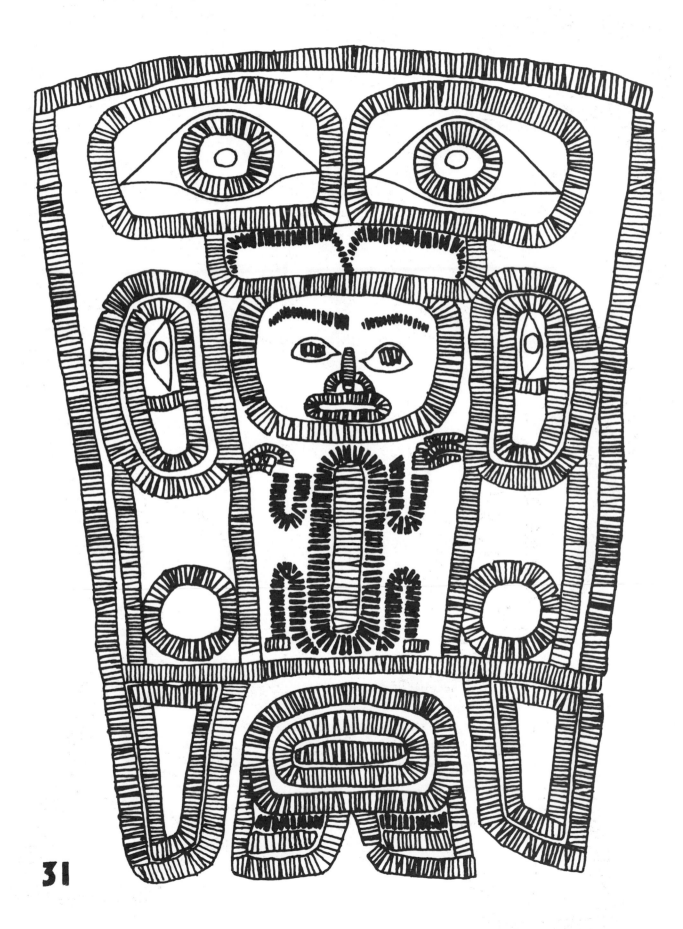

31

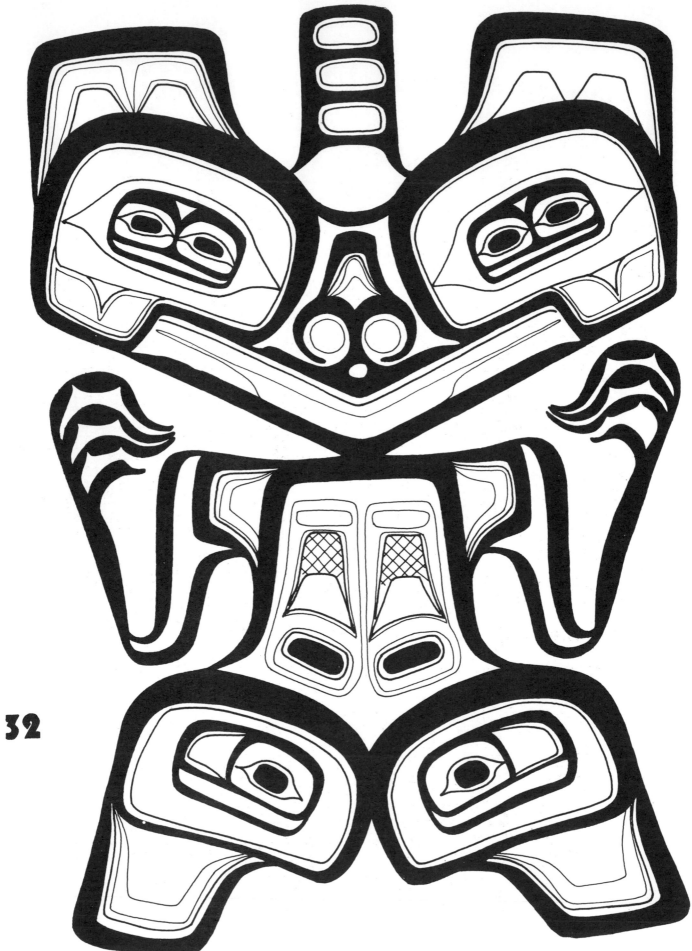

32

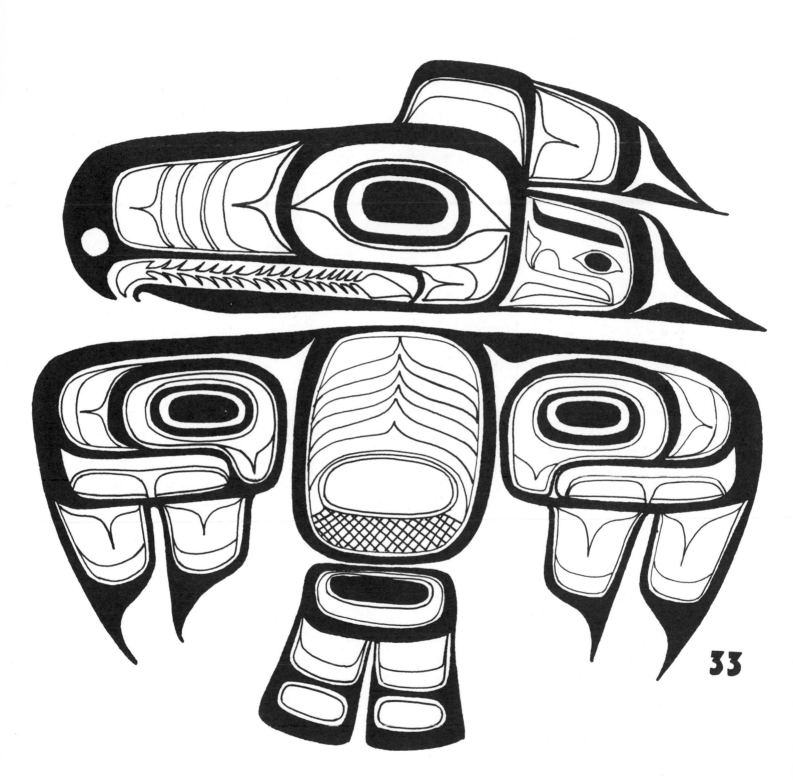

33

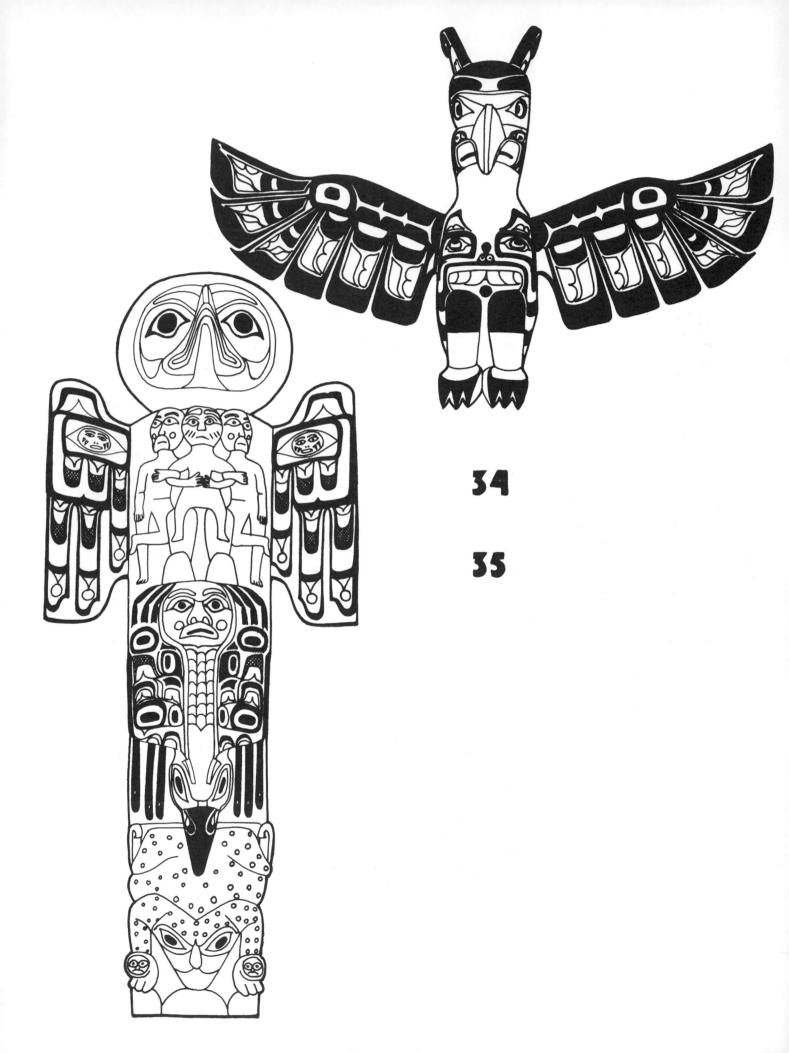

34

35

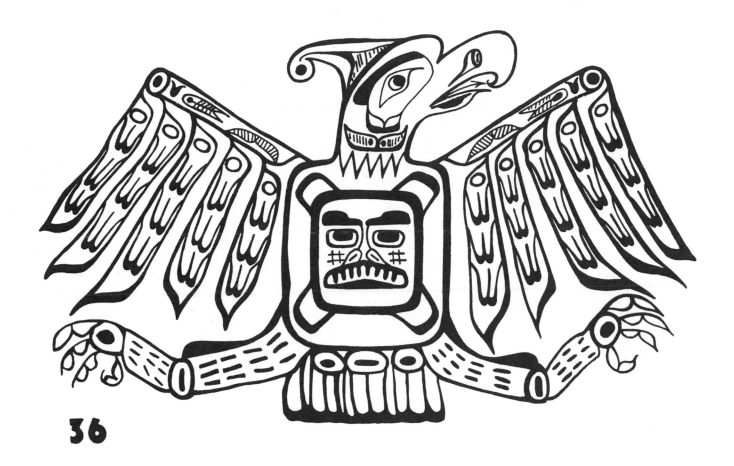

36

37

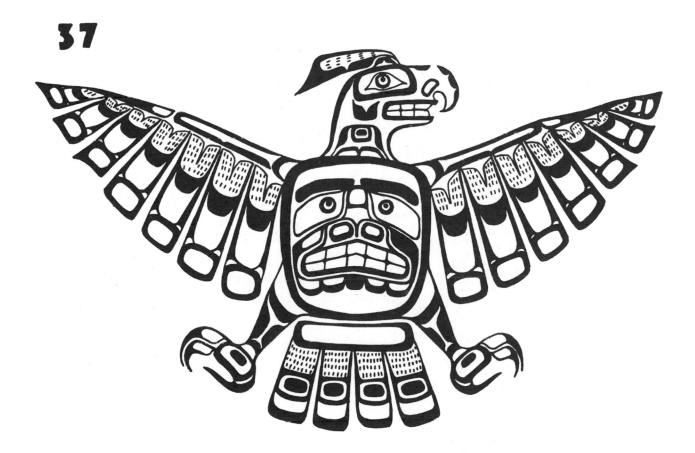

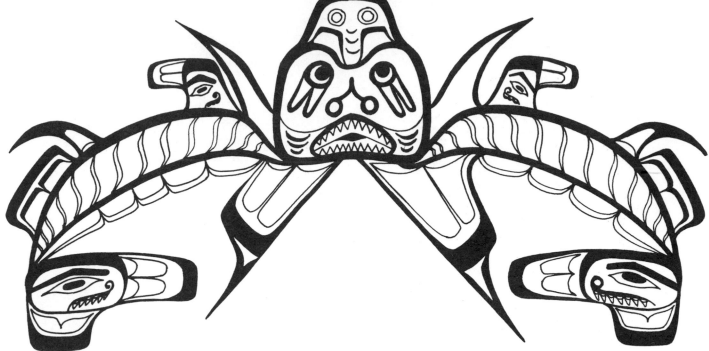

38

39

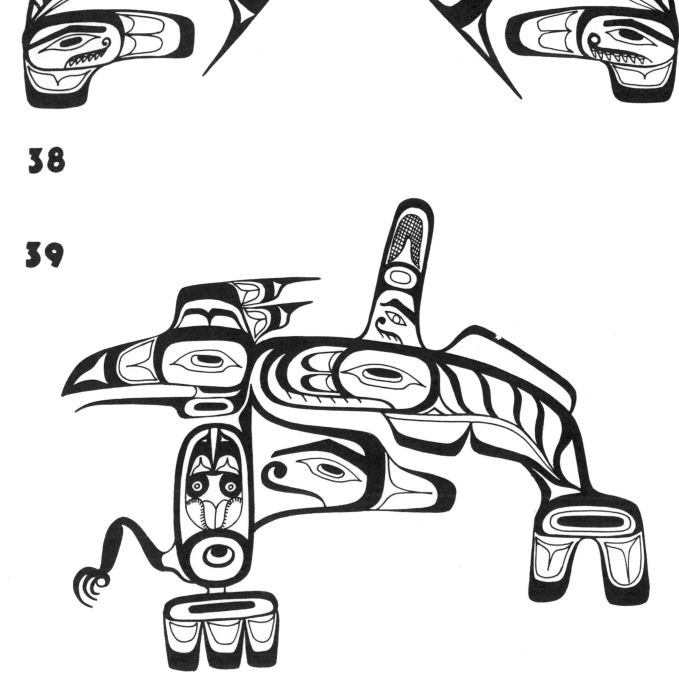

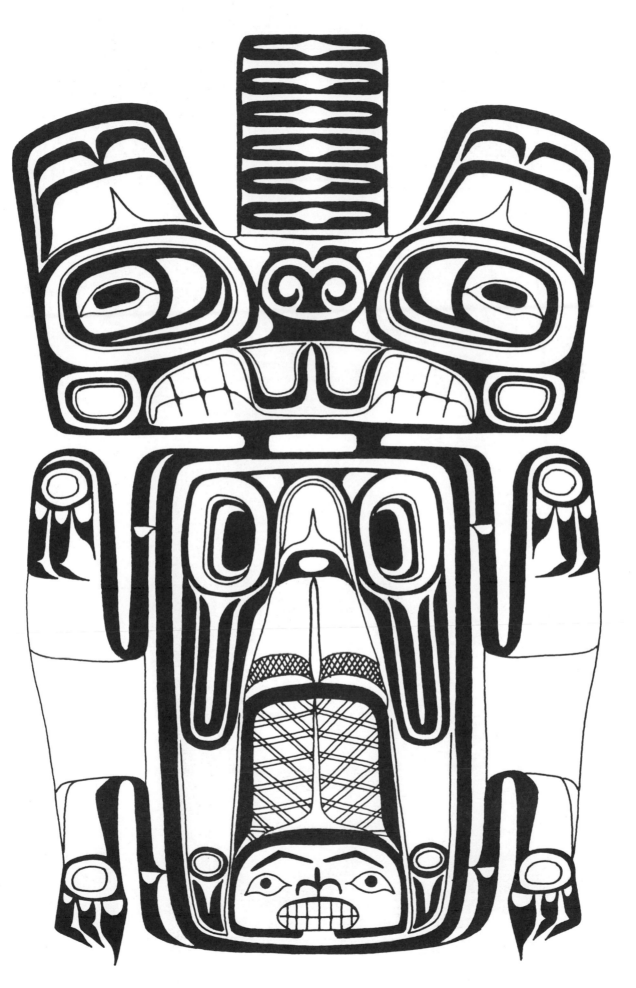

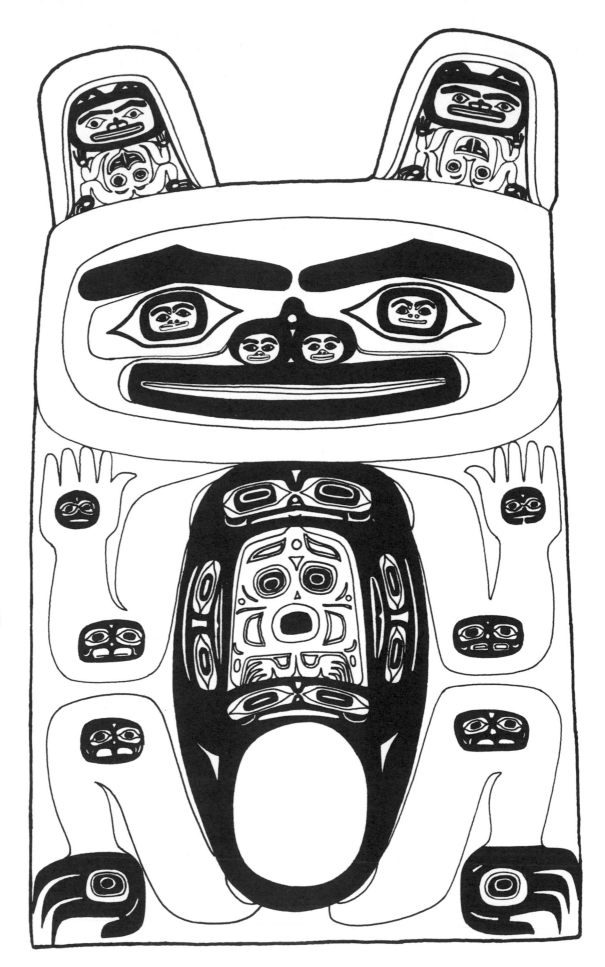

41

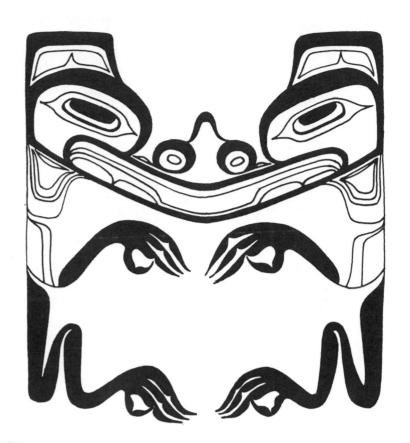

42

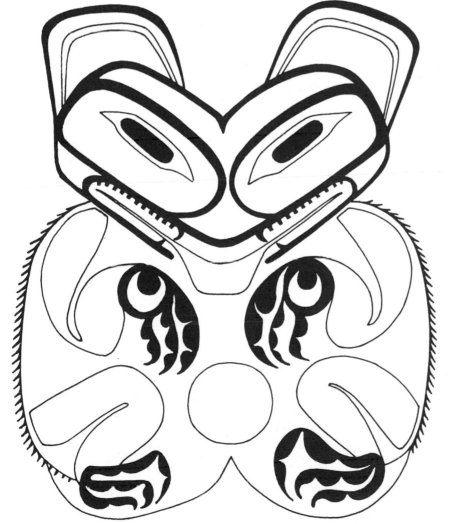

43

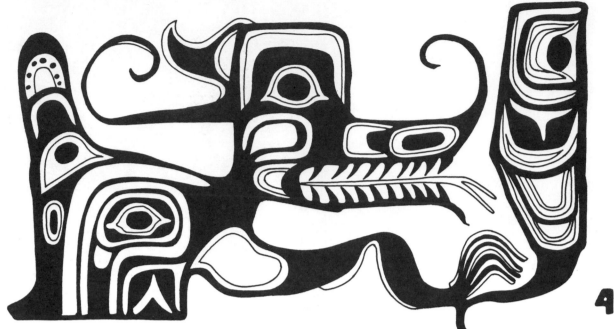

44

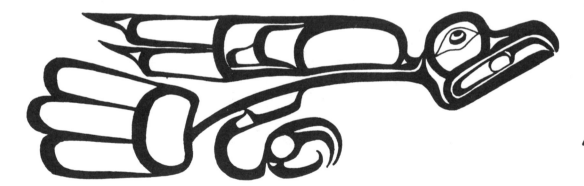

45

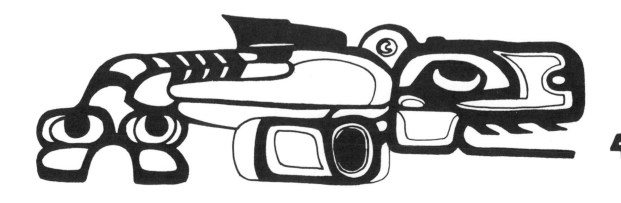

46

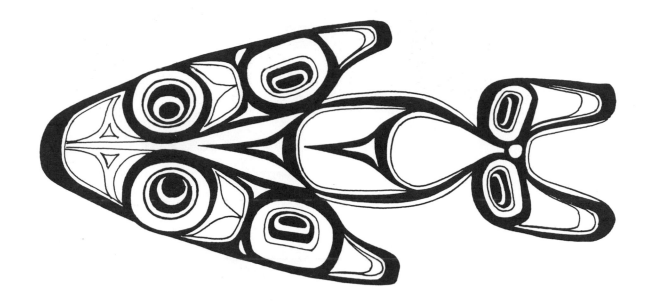

47

48

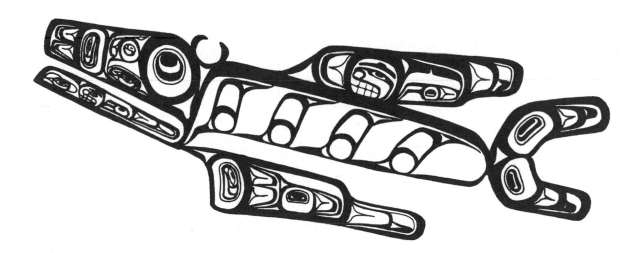

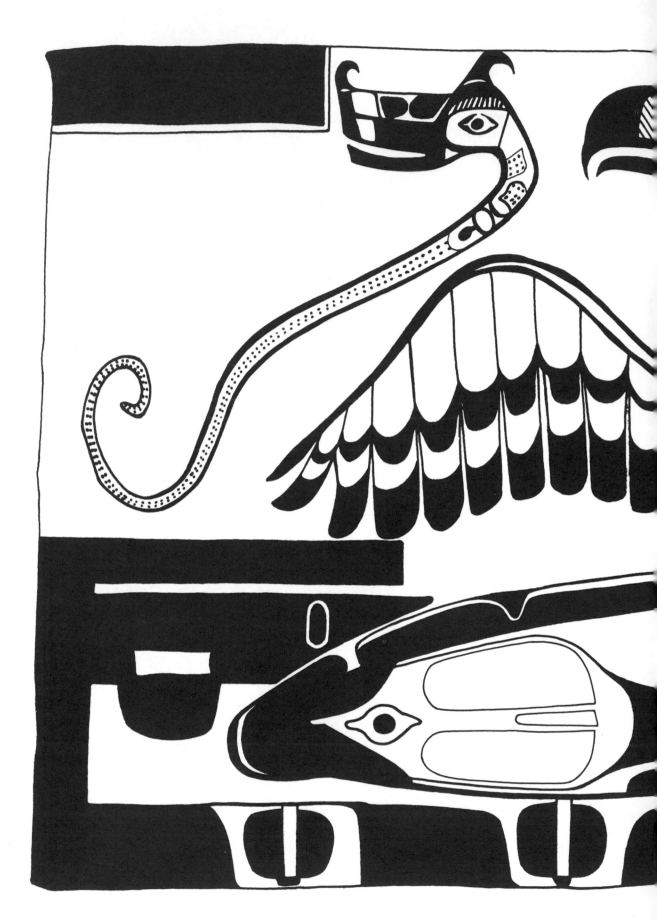

49

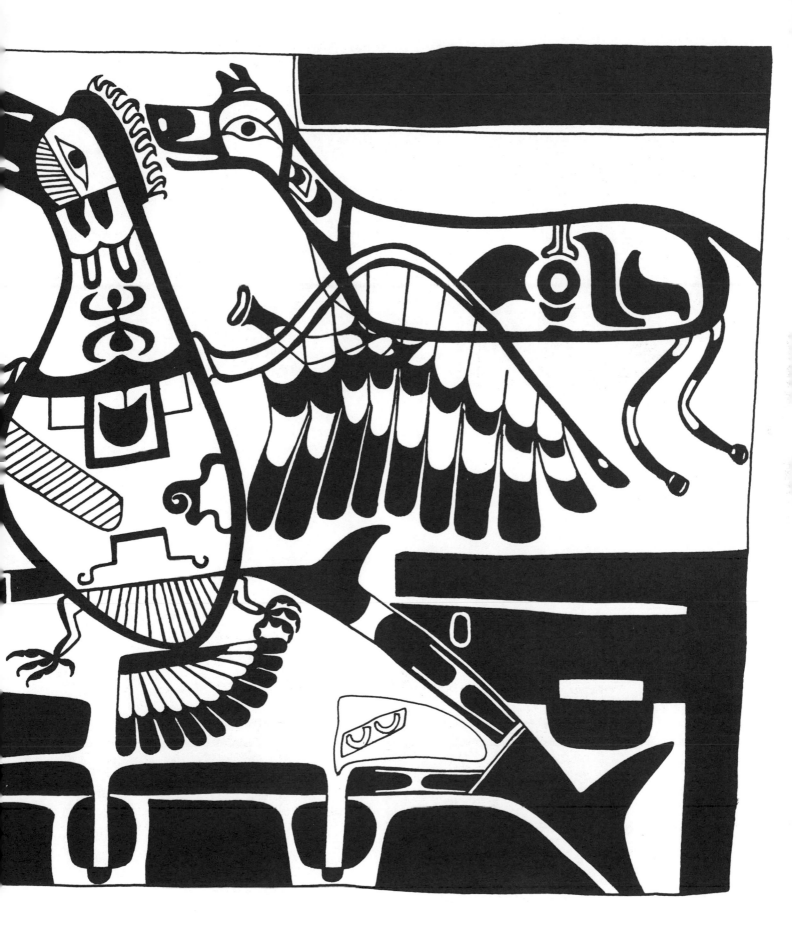

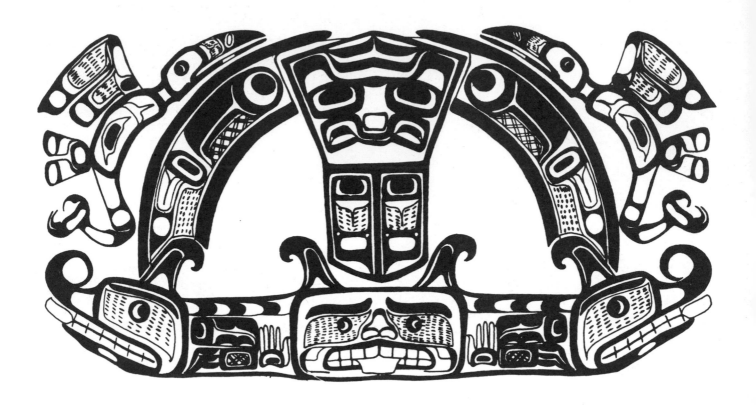

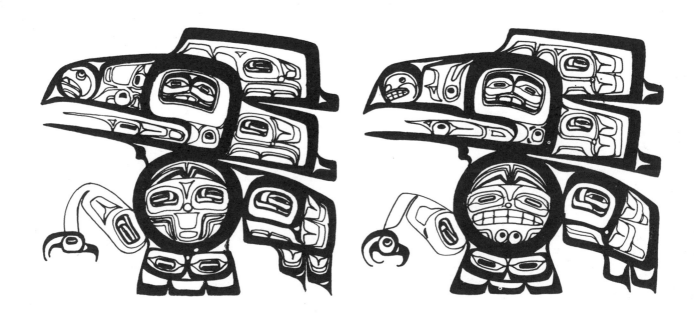